# SOCIAL ANIMALS

# SOCIAL ANIMALS

### A BERKLEY BESTIARY

*Illustrated by Ryan Berkley*
*Stories by Lucy Berkley*

SASQUATCH BOOKS
SEATTLE

## FOR JIMMY JOE

Printed in China

Published by Sasquatch Books

19 18 17 16 15          9 8 7 6 5 4 3 2 1

Editor: Hannah Elnan
Production editor: Em Gale
Design: Joyce Hwang
Copyeditor: Emma Reh

Library of Congress Cataloging-in-Publication Data is available.

ISBN: 978-1-63217-040-8

Sasquatch Books
1904 Third Avenue, Suite 710
Seattle, WA 98101
(206) 467-4300
www.sasquatchbooks.com
custserv@sasquatchbooks.com

# CONTENTS

# INTRODUCTION

**WELCOME, FRIENDS,** to a collection showcasing the charming portraits and charmed lives of twenty-seven of society's most extraordinary beasts. These civilized ladies and gents have permitted our esteemed artist and biographer to immortalize them in picture and prose. Prepare to delight in the sartorial splendor of the Berkleys' menagerie, and marvel at the array of life endeavors represented in their stories.

Among many others, you'll meet a high-society heifer, a hen with a fashion firm, a meerkat with multiple talents, and a grizzly who can't bear to sleep his winters away. Whether their creature craving is social influence, corporate power, or simply the pursuit of a peculiar personal obsession, these beasts can't help but be the particular animals they are.

Let their examples inspire you to proudly display the true colors of your own feathers or fur.

# SOCIAL
# BUTTERFLIES

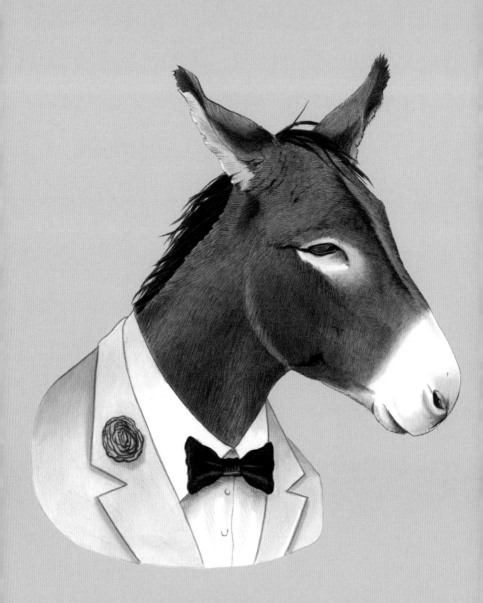

# THE DASHING DONKEY

**O**VERDRESS TO IMPRESS IS more than casual advice to this jackass, and he expects no less from his fashionable friends. Stubbornly devoted to formal wear, he sees no shame in picking pals based on the symmetry of their Windsor knots. He is so dedicated to his mission that he dons this white tuxedo daily for his morning jog. The only burden for this beast is a wrinkled dress shirt.

# THE CULTURED COW

**S**OME COWS JUST DON'T FIT IN on the farm. This Jersey girl left home for the city, swapping rustic green pasture for swanky brownstone. Now that she's a noted personality among uptown elites, she amuses herself by playing patron to a herd of downtown artistes. She even hired this struggling bird as her butler while he seeks his big break on Broadway. It's a real win-win.

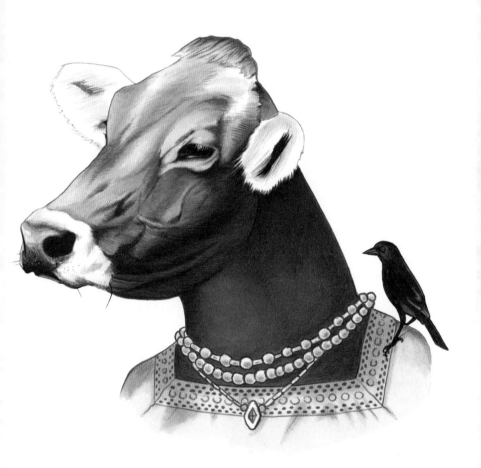

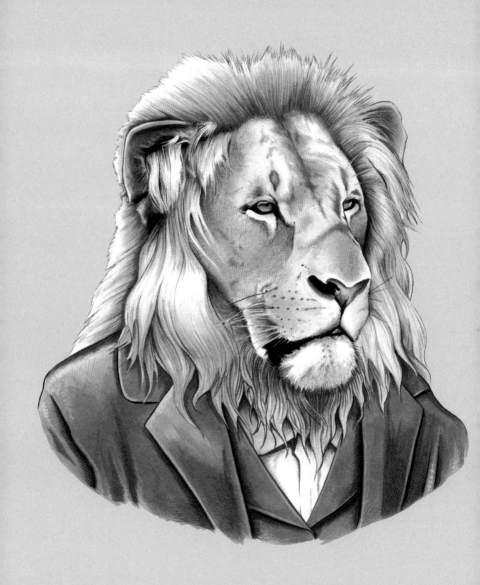

# THE LOQUACIOUS LION

**A**FTER YEARS OF COMPLIMENTS on his luscious locks, this lion launched The Mane Man, his dream salon and hair care line. His eye for hair is only matched by his nose for gossip, and his salon doubles as the hub for the latest townie buzz. His clients make weekly appointments to keep up on their roots and the drama. A real juicy bit of news entitles the customer to a free scalp scrub.

# THE CHARMED CAT

**A**FTER HITTING SIXTEEN straight scratch ticket jackpots, this black cat realized she wasn't bad luck at all. Kismet carried her to Vegas where her knack for blackjack got her blacklisted at every casino on the Strip. She missed the attention as much as the winnings, so she seized the opportunity to merge her charisma with cash. Now passing tourists offer her big money just to cross their paths.

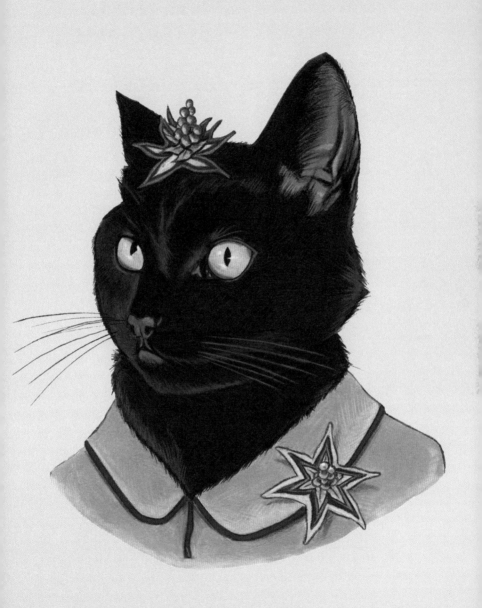

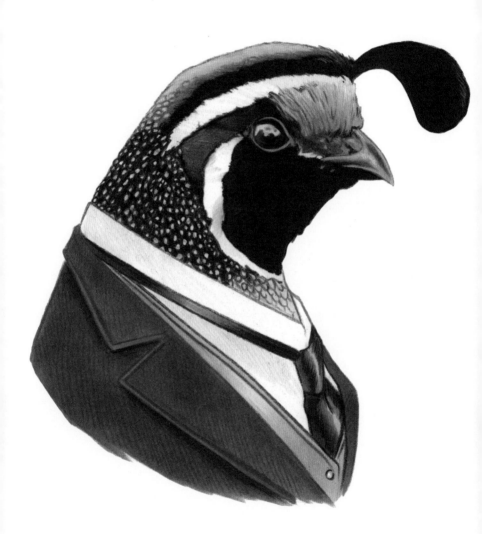

# THE QUIRKY QUAIL

**A**S A CHAMPION OF CALIFORNIA bird causes, this quail travels the Golden State hosting luncheons and community fundraisers. When he wants to accentuate a point, he quickly bobs his head and his well-coiffed plume provides a visual exclamation point. Marketing analysis shows that the more bounce in the plume, the more donors open their wallets. Record donations poured in after an unprecedented fifty-seven bobs in a two-minute rally speech.

# WORKER
# BEES

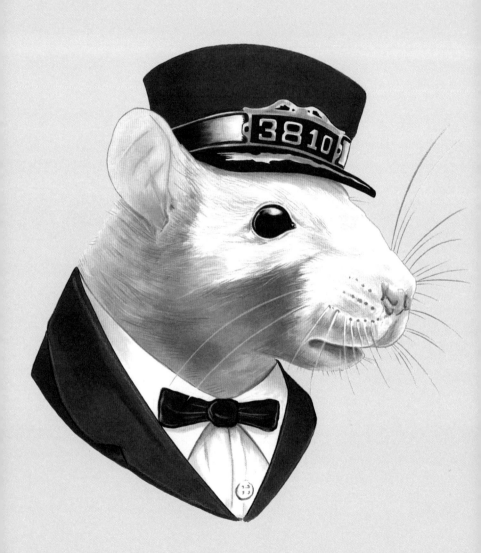

# THE RELIABLE RAT

**F**OR FORTY YEARS, THIS self-proclaimed "Emissary to Entertainment" operated the express line to Coney Island while broadcasting witty bulletins about area amusements. When he retired, the transit authority gave him a golden wristband granting him free Skee-Ball for life. If he's spotted on the midway, he'll accept cotton candy in trade for revealing a secret about the legendary Cyclone, his favorite ride.

# ☙THE☙ SAVVY SKUNK

**R**ELUCTANT TO BE SUCKED into the family trade of vacuum sales, this skunk had his entrepreneurial epiphany. He developed his sense for scents into a thriving aromatherapy business with oils, candles, and other fragrant concoctions. His perennial best seller is a tomato juice body scrub that clients can't get enough of after his potent in-home demonstrations.

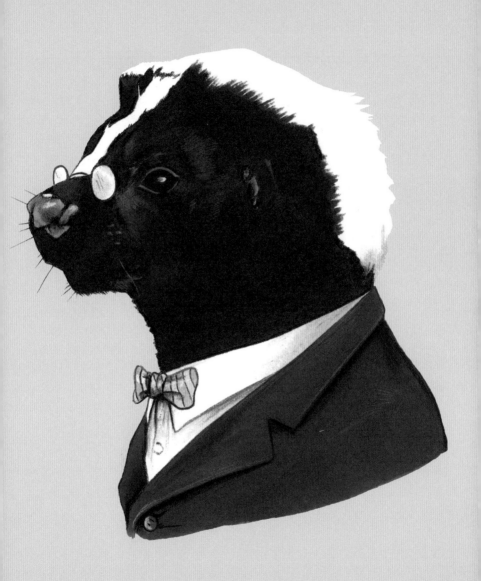

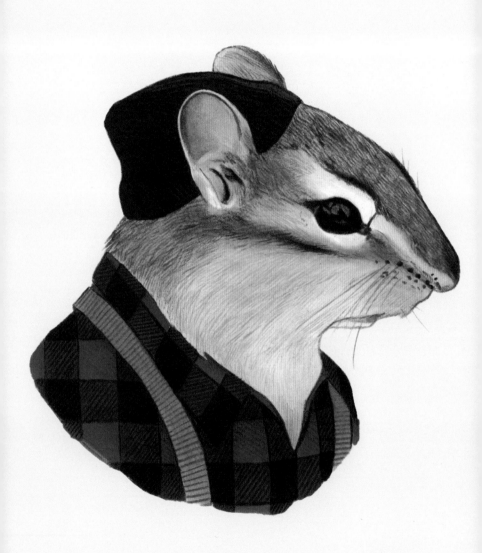

# THE CRAFTY CHIPMUNK

**W**HEN HE WAS YOUNG, THIS whittling chipmunk started carving faces into acorns despite his mother's refrain, "Don't play with your food!" Engraving edibles became his nine-to-five, but his passion project is a life-size wooden replica of Babe the Blue Ox. He runs an acorn concession stand at lumberjack contests to support his never-ending need for bright blue paint.

# ᴛʜᴇ DEDICATED DOE

**A**S A DELINQUENT FAWN, THIS deer did her share of unauthorized munching in neighborhood gardens. Now that she's grown, she uses her ill-gotten botanical expertise for nobler ends. As a Master Gardener, she renews the landscapes she once abused, and she's even partnering with the aptly named Department of Energy (DOE) to fashion a fancy set of solar-powered sprinklers.

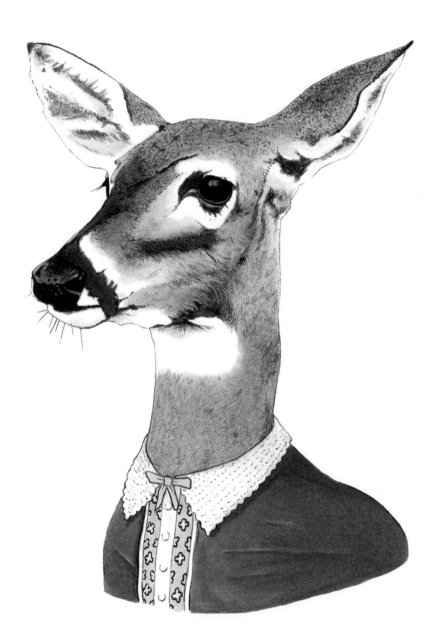

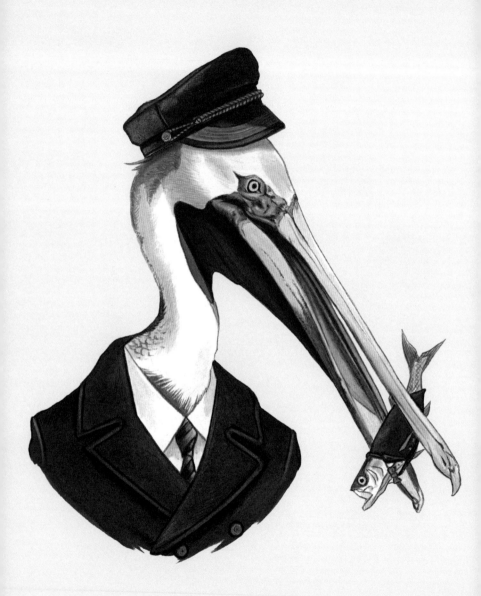

# THE PLUCKY PELICAN AND THE HELPFUL HERRING

**H**AULED ABOARD THE PELICAN'S ocean trawler, this educated herring was eager to be useful as something other than the catch of the day. Using his proprietary system for ocean climate charting, he warned the captain of a brewing storm and saved the bird's life along with his own. Desperate measure turned to occupational opportunity, and the fish landed a job as the seacoast's most trusted television weatherman.

# ODD
# DUCKS

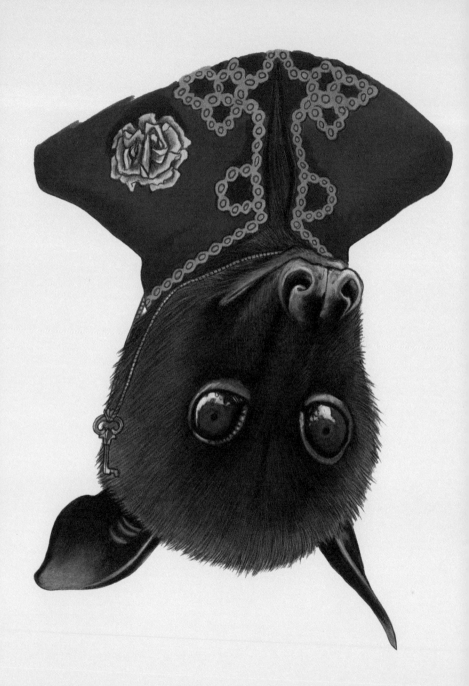

# THE BROODING BAT

**O**BSESSED WITH ORGAN music and dancing in the dark, this lonely girl could never hang with the cool kids. Everything changed on her sixteenth birthday when the Cave Circus swooped into town. She joined the troupe with her own fruit-fly act, choreographing elaborate gymnastic routines for her wee performers. Their grand finale involves a daring series of somersaults on the head of a match.

# THE MYSTIFYING MEERKAT

**A**PPEARANCES ASIDE, THIS fellow is no ordinary flying ace meerkat. He's also a Dixieland pianist, skilled painter, and former owner of the world's largest model-Porsche collection, but he traded it for a biplane and a candy bar. Artists, pilots, and collectors alike find him at the watering hole to seek his absurdist advice, which usually comes wrapped in a joke and sealed with a wink.

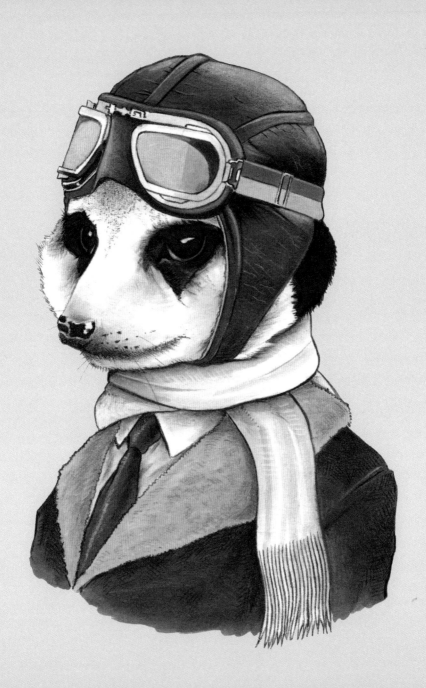

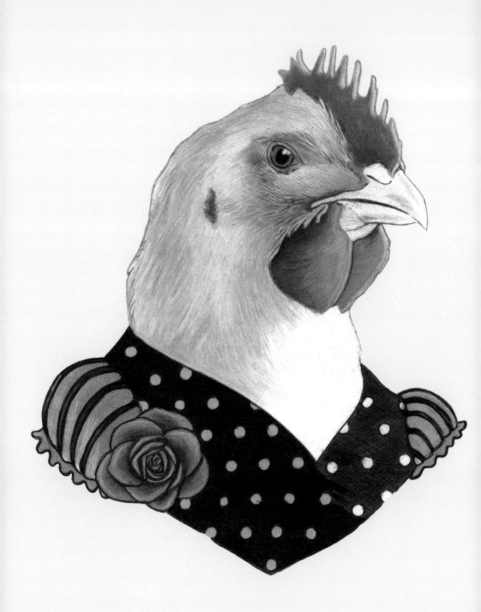

# THE CHEEKY CHICKEN

**T**HIS CHICK HAS BEEN A FAN of eccentric fashion since literally before she was born. In one of the only documented cases of the rare ovum polkaditis, the egg she hatched from was speckled with purple and orange polka dots. As a grown hen, she embraced her barnyard birthright and launched a popular line of chicken finery from her design house, BaGawk! Enterprises.

# THE BEGUILING BADGER

**I**N A DEN AS SWANK AS ITS owner, this badger digs role-playing of all sorts. *Ill-Behaved Bill!*, his one-man Shakespearean revue, is an underground hit. As a gifted Dungeon Master, he stages epic campaigns in his own realms. This gent also has skills that don't depend on rolling dice. His wizardry with women earns him plenty of experience points in the real world.

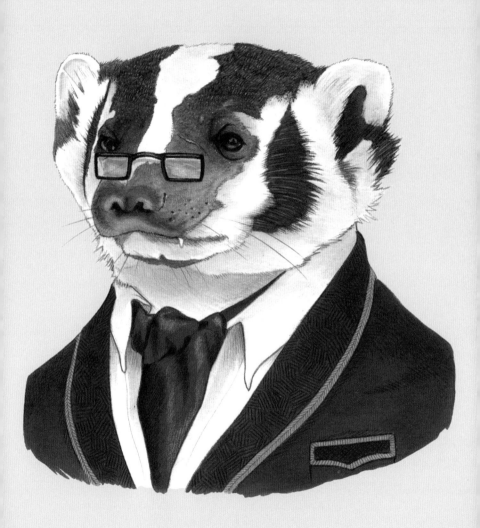

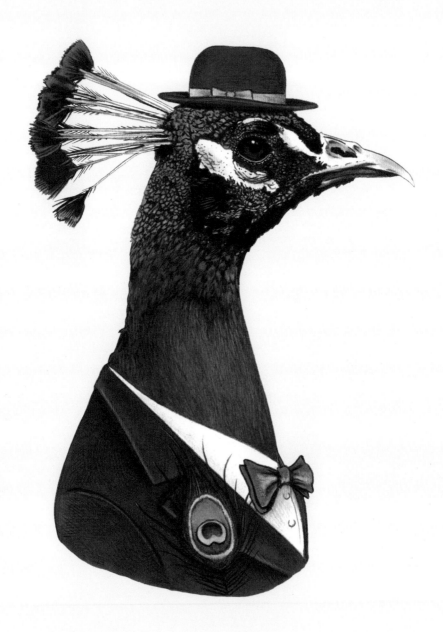

# THE PASSIONATE PEACOCK

**W**HILE HE LOVES PICKING a banged-up banjo on a dusty porch, this troubadour can't deny his puffed-up peacock heritage. No matter how ramshackle the musical venue, he always sports a bow tie and bowler combo and preens in the mirror before performing. He isn't above poking fun at himself, however. His bluegrass rendition of "You're So Vain" is a guaranteed crowd pleaser.

# TOP
# DOGS

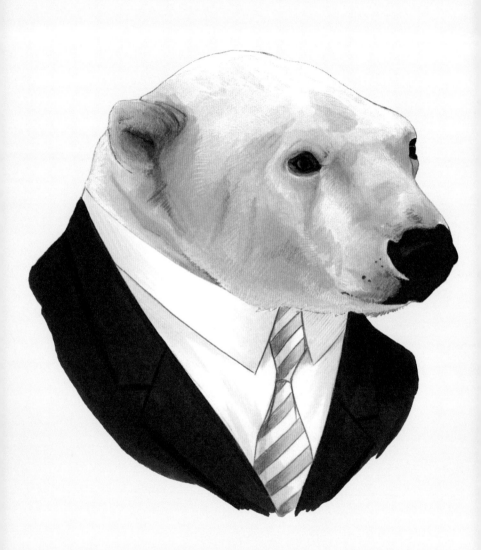

# THE PROMINENT POLAR BEAR

**THIS FELLOW IS CHAIRMAN** and genius-in-residence for a booming ice pop enterprise. He tinkers with flavor formulas so sought after that he keeps them in a briefcase handcuffed to his paw. Although his name is on a corner office, he takes his meetings in the walk-in freezer of the cafeteria downstairs. Applicants need earmuffs and parkas for job interviews, but they leave with a complimentary frozen treat.

# THE REPUTABLE RAPTOR

**A**S PRESIDENT OF THE RED Tail Society, this hawk has a distinguished reputation to uphold. His recent tendency to squint during rodent reconnaissance missions revealed he has a hint of myopia. Moved to help the similarly stricken, he founded Spectacles for Ocularly Afflicted Raptors, or SOAR. The organization distributes eyeglasses to proud birds of prey, who welcome the chance to uphold their eagle-eye reputations.

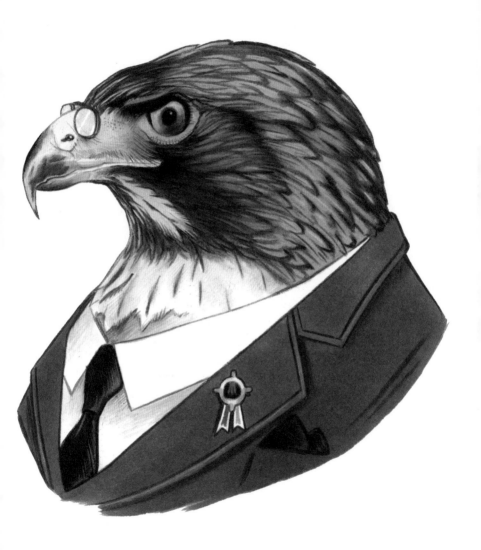

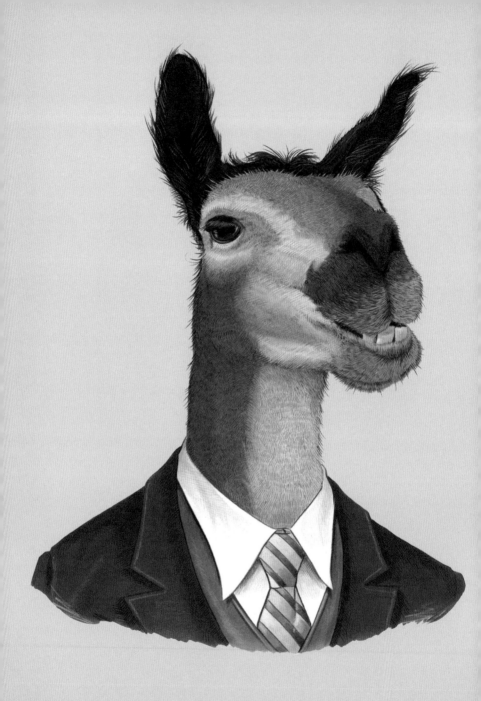

# THE LAUDABLE LLAMA

**F**ROM HUMBLE BEGINNINGS AS A sesame seed spatterer, this llama climbed the novelty-expectorating ranks to head the Worldwide Watermelon Seed-Spitting Board. Although he couldn't spew a middling distance at first, he loves to recount how passion, practice, and a folded-tongue technique propelled his career forward like a hurtling seed. His latest event innovations include a seasonal pumpkin seed relay and an avocado pit bonus round.

# ☶ THE POWERFUL PIG

**T**HERE IS NO BIGGER PLAYER in the pigpen real estate game than this hog boss. He's pulled down every prize in porcine property peddling, even scoring the coveted Golden Snout two years running. With his cool concepts for urban core renewal, he has revitalized filthy neighborhoods, taking them from sty to stylish. Despite persistent rumors to the contrary, he keeps his own office spotless.

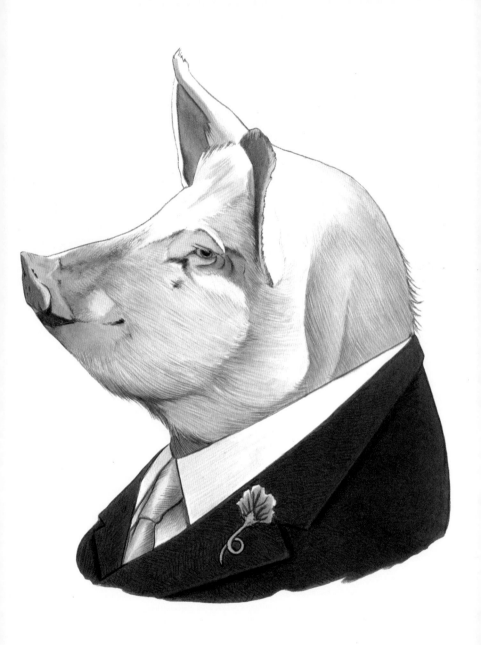

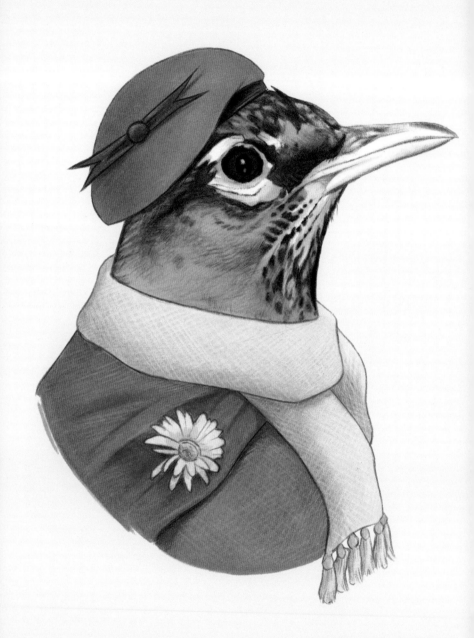

# THE RIVALROUS ROBIN

**T**HIS EARLY BIRD GETS FIRST dibs on the *New York Times* crossword. Introduced to the pastime by a cruciverbalist chickadee, the confident robin works her downs and acrosses in permanent ink. She's won nationals seven times but still holds a grudge against a shrew who once outpuzzled her. She doesn't mean to be derogatory: her toughest competitor is truly a puzzle-savvy shrew.

# BLACK
# SHEEP

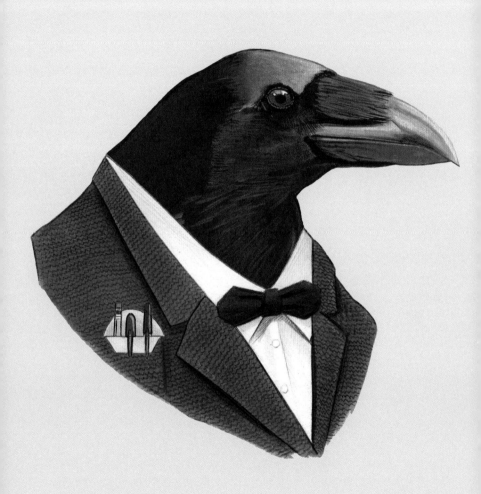

# THE RADICAL RAVEN

**W**ITH A HOT TEMPER AND a double PhD in philosophy and math, this raven earns his rep as an intellectual bad boy. He's ruffled a few feathers with his theory that bird existence is merely a cosmic manifestation of the Pythagorean theorem. His cerebral adversary is his half sister, a self-taught crow with spiritual roots. Their dumpster-side debates make epic entertainment for the alley intelligentsia.

# THE GREGARIOUS GRIZZLY

**U**NBEKNOWNST TO HIS family, this grizzly bear loathes hibernating. Every fall, after his kin settle down in their den, he dons what he calls his "city camouflage" and sneaks out to enjoy the spoils of metropolitan living. When he's not ice-skating, playing laser tag, or downing cappuccinos, he has been caught occasionally nodding off.

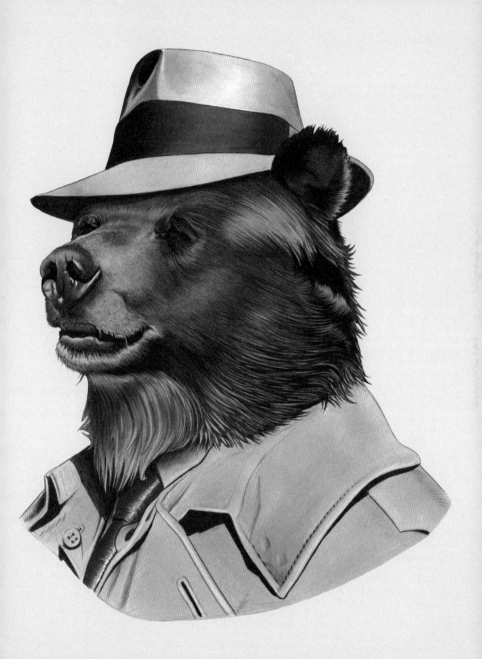

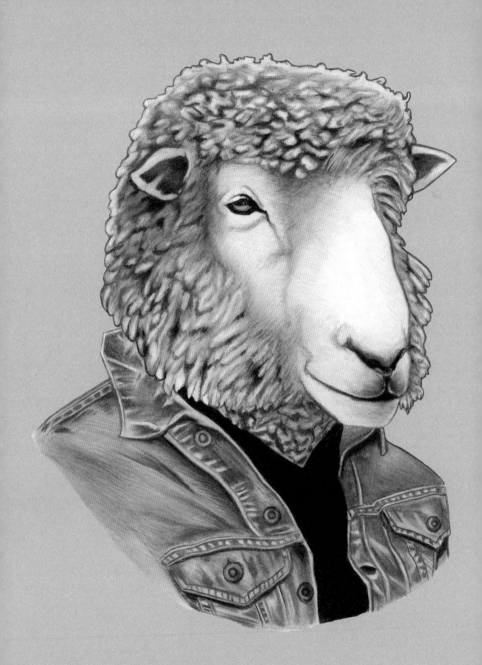

# THE SUPERSTAR SHEEP

**D**ESPITE HIS SUCCESS AS a rock singer, this sheep never found his social niche. As a defiant lamb, he made a name in hardcore punk, but now he finds himself identifying with The Man. If he didn't have a professional image to maintain, he'd wear khakis instead of ripped jeans. His latest hit, "Misfit Among Misfits," subtly explores this inner angst.

# THE PERPLEXING 'POSSUM

RUMORS ABOUND AS TO why this opossum moves through the night with a mysterious purpose. Townspeople often spot his caped silhouette scuttling past the post office or playing dead near the wharf. He's even been known to make secretive stops at the 7-Eleven. Some say it's lost love, some say he's a spy, but most believe he just revels in his status as the village enigma.

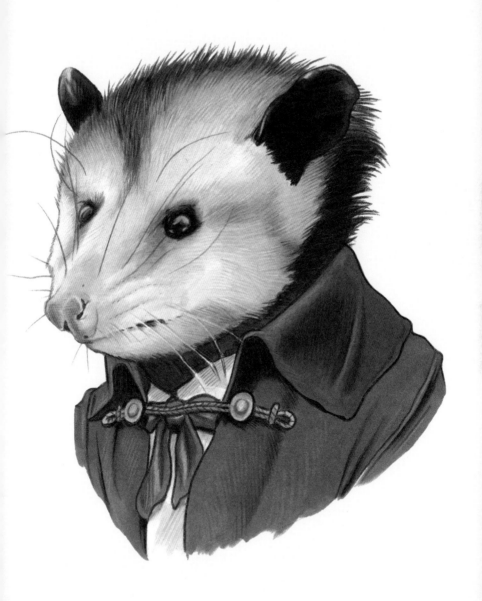

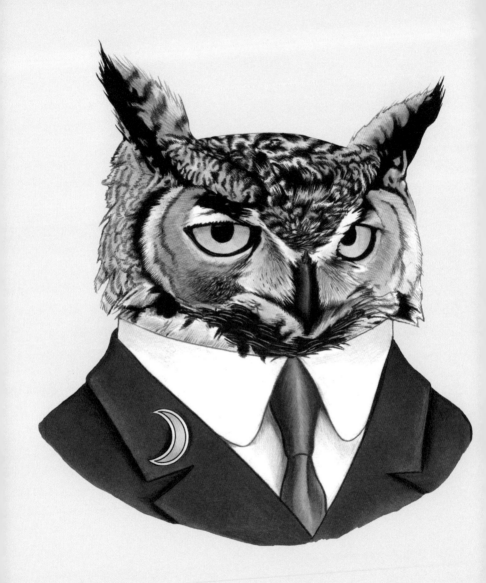

# THE OBSESSIVE OWL

**S**INCE HIS OWLET DAYS, THIS gent has dreamed of flying to the moon, but until recently, he spent all his time partying with the night owls. Now that he's rediscovered his ambition, NASA won't give him the time of day. Until they approve his application, he trains in a treetop anti-gravity chamber he made from pellets, twigs, and a very long string.

# LONE
# WOLF

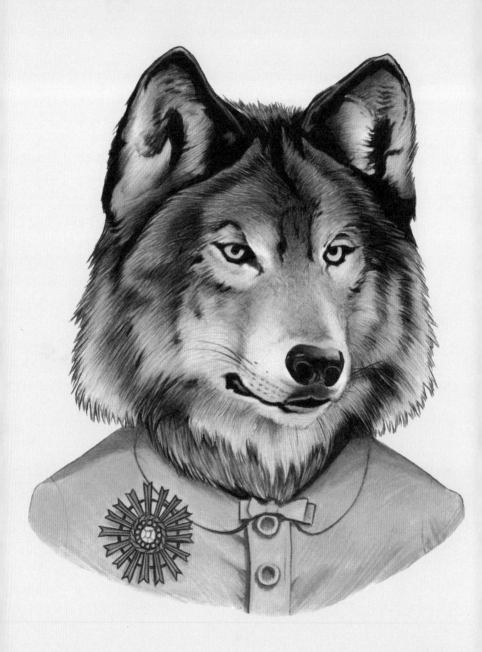